HARRY IN 30 IMAGES

A visual story of his biggest moments

Hardie Grant

BOOKS

CONTENTS

INTRO

Harry Styles is one of the most entertaining celebrities of the 21st century. With his message of kindness, flamboyant style both on and off the stage, and that iconic hair, he beams joy and sunshine out into the world. Between his natural adorableness and his ground-breaking fashion adventures, he is one of the most photogenic people in the world. This book tells the story of his life in 30 incredible images.

Every step of Harry's journey to stardom has been documented, given that he started life as a popstar the old-fashioned way: being discovered on a talent show. A 16-year-old boy with no industry connections or stage school training, he relied on his cheeky smile, natural charm and a sweet singing voice to catch the attention of Simon Cowell, the head judge on *The X Factor*. He was selected as one-fifth of the group One Direction. Harry put in the hard work of being a boybander, spending years touring, recording albums and shooting music videos. The hard work paid off because One Direction became the biggest boyband in decades, selling millions of records and playing stadiums all over the world.

From the start, Harry was the One Direction boy who stood out against the rest. His commitment to entertaining the crowd along with his increasingly offbeat fashion choices combined to create a special place for him in Directioners' hearts. When the group went on indefinite hiatus in 2015, he seemed poised to be the breakout solo star. But instead of grabbing chart status with a ballad or big dancepop song, he took his time to live life and decide what genre he really wanted to experiment with. When he eventually returned to music, it was in a surprisingly rocky direction. The floral suits he had begun wearing during his One Direction days developed into an incredible wardrobe of suits in a rainbow of colours and patterns, reflecting his refusal to conform to boring gender norms.

As he grew in musical confidence, Harry's music became more playful. His seemingly endless *Love on Tour* live show became famous for its happy and welcoming atmosphere, and for being a venue for his fans to show off their Harry-inspired outfits. When he released his second solo album *Fine Line* in 2019, he gained a huge new fandom who loved

his "fashion grandad" style of jumper and pearls, and his radio-friendly bops such as "Watermelon Sugar" and "Adore You". His cheeky sense of humour, slow drawl and, let's be honest, his arm muscles sparked a new wave of fame. Harry started racking up number one songs and albums from this point, culminating in a triumphant Grammy win for his third solo album, *Harry's House*.

Harry looks like a Hollywood idol and so it was natural he would move onto the silver screen and start acting. He has starred in British and American movies, choosing smaller, quirkier films over blockbusters. As ever, Harry was keen to learn from experts like director Christopher Nolan, rather than cashing in with star vehicles. We got to see a different side to his talents in the sweeping *Dunkirk*, and the character-driven movies *Don't Worry Darling* and *My Policeman*. The red carpet wasn't ready for Harry's movie premiere outfits!

Although he's made his mark on Hollywood and conquered the world of pop, Harry remains humble, constantly reminding interviewers that he's where he is because of the

ans. Known as one of the most stylish
op fandoms, Harry's fans have stuck
y him throughout his career. They
ave embraced his different musical
irections and used him as a source of
nspiration. Even other celebrities can't
top praising Harry for his politeness
nd talent. He has somehow remained
he cute cupcake who first walked
nstage for *The X Factor*, even while
asking in all the glorious attention.

THE SPOTLIGHT LOVES HARRY. THE CAMERA LOVES HARRY. WE LOVE HARRY! LET'S TAKE A JOURNEY THROUGH 30 INCREDIBLE HARRY MOMENTS.

X FACTOR

"Hello, I'm Harry Styles."

In 2010, there was no bigger platform than *The X Factor*. Harry was just 16 years old, his first year of eligibility to audition. He travelled with his mum Anne and sister Gemma to sing in front of Simon Cowell, Nicole Scherzinger and Louis Walsh. They had no idea that before long, this curly-haired boy would be more famous, and have more fans, than all of them combined.

Showing no signs of nervousness, Harry chatted with label boss and industry player Simon, showing off his knowledge of baked goods and his plans for college. Spoiler alert: Harry will not see the inside of a school again.

Then he sings his first song.

Singing "Hey, Soul Sister" by Train, the trademark Styles sparkle is already there. He catches the eye of people in the audience, unleashing his smile on them. It's obvious that he has the sauce, the charisma, that magical "it" that makes someone a star. The crowd loves him.

Simon acts like he isn't sure whether to put Harry through and makes him sing another song. Harry chooses "Isn't She Lovely" by Stevie Wonder, which is much more suited to his voice. On the strength of this performance, he makes it through to the next round. Here the challenges pile up: as well as being able to carry a tune and charm an audience, he needs to be able to dance. Along with a group of other boys, including a reluctant lad from West Yorkshire named Zayn Malik, Harry tries his best to make it through a dance routine. What he lacks in coordination, he makes up for in commitment, but it isn't enough.

It's bad news. Harry hasn't made it through. He and the other rejected, dejected boys get ready to leave. Among them is Liam Payne, who tried out the year before and saw this as his second chance at fame.

But then, Simon throws them a lifeline. He calls five boys back in front of the panel to ask if they would consider going forward as part of a boyband? Along with Harry he's chosen Zayn, Liam, an

ish boy called Niall Horan and another
orkshire boy named Louis Tomlinson.
hey don't even need to answer; they
ust jump into an ectastic group hug
ke five excited puppies. Harry later
aid: "I was completely up for it." All that
emains is to come up with a name for
heir band.

he world's hottest new boyband
One Direction (name picked by Harry)
makes it through to the live shows on
heer earnest adorableness. These are
vatched by millions every Saturday and
unday night, and the public takes notice
f Harry. Every week the boys go out
nstage and their infectious enthusiasm
harms everyone from teenage girls to
heir mums.

hey don't win *The X Factor*, but who
ares? The real work of being in One
irection, and the real superstar story
f Harry Styles, begins when the show
 over.

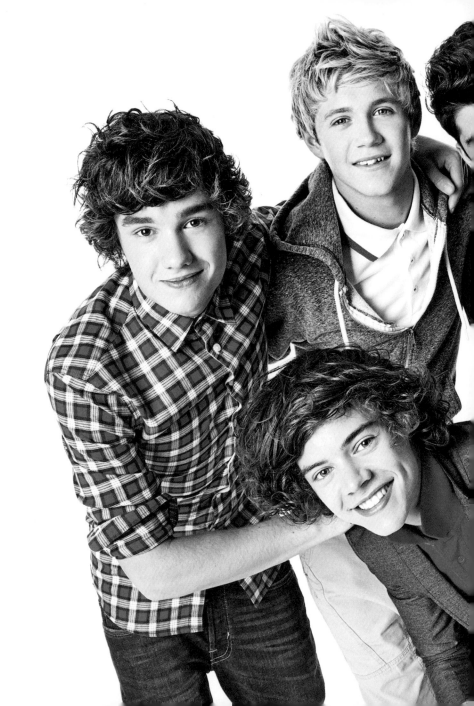

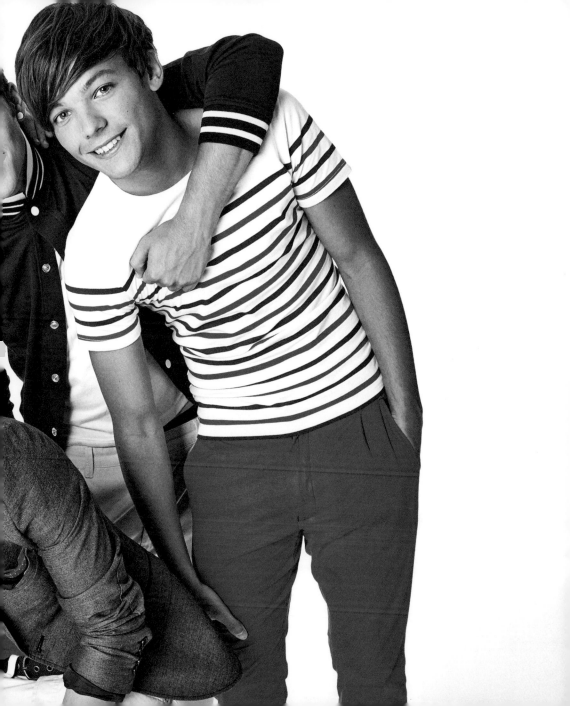

FIRST ONE DIRECTION ALBUM

In November 2011, the UK and Ireland got the chance to hear the first One Direction album *Up All Night*. American fans inundated the record company with requests for the album to get a US release. Because this was before streaming really found its feet, they only succeeded in hearing the album one week earlier than planned. This is probably the last time Directioners failed to get what they wanted!

In the great tradition of boyband records, *Up All Night* translates the sweet, fun chemistry of the group's members into 13 tracks about the happiness and heartbreak of love. In a world that doesn't treat girls very well, the best boyband albums are a safe listening space where it's okay to be vulnerable and risk falling in love. *Up All Night* delivers.

Other than the huge first single "What Makes You Beautiful", the album's best songs include "More Than This", a heartfelt ballad with a Europop laser-synth beat unexpectedly dropped into the chorus. "Moments", a song added to the deluxe edition, is the first time one Mr Ed Sheeran will write a song for One Direction, but not the last. "Na Na Na" has an elite nonsense pop lyric, as you can guess from the title (hint: "na na na"). The album's best track is the very last one, a perfect blend of energetic vocals, laser sounds and romantic yearning called "I Should Have Kissed You".

Each boy would develop their own voice as time went on, but Harry's natural tone, fearless belting ability, and the way he sang the intimate, romantic songs made him a standout from the start. He got more solo singing time than any of the others on this album, at seven whole minutes and 18 seconds, 10 seconds more than Liam in second place.

Up All Night was an instant hit, making it to number one on the US Billboard chart. The world's greatest band (bar none!) had arrived.

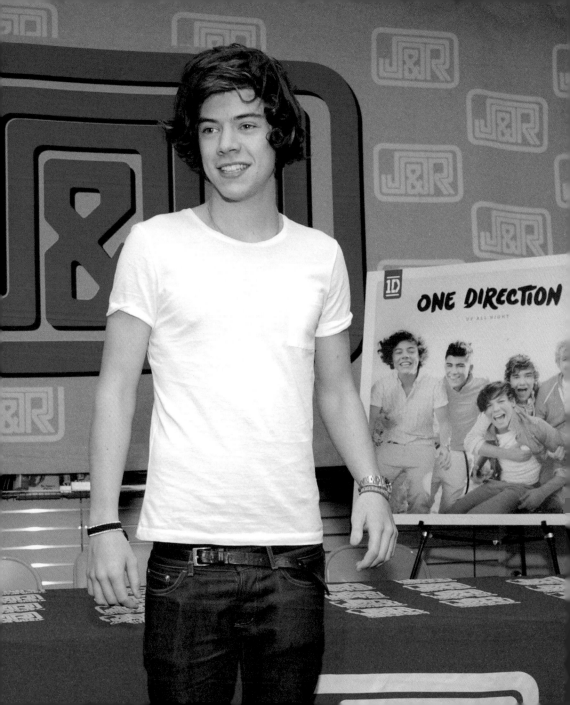

MTV VIDEO MUSIC AWARDS

In September 2012, One Direction performed at the MTV Video Music Awards. Pop's most culture-defining moments have happened at the VMAs, from Drake declaring his love for Rihanna to Kanye interrupting Taylor Swift. It was a huge moment for 1D.

The band rose from beneath the stage into the middle of a crowd of girls, screaming in the way only a group of women suddenly confronted with Harry Styles can scream. The cameras cut from the girls having the time of their lives to bored music industry people. This is the 1D story: either you get it or you don't.

Harry obviously loves the music, air drumming along to the track and dancing his heart out. No wonder he was happy: One Direction won three awards that night, including Best New Artist.

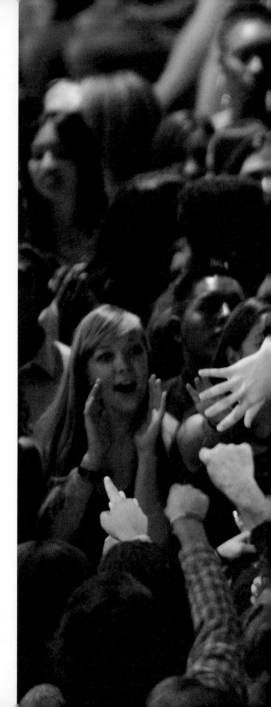

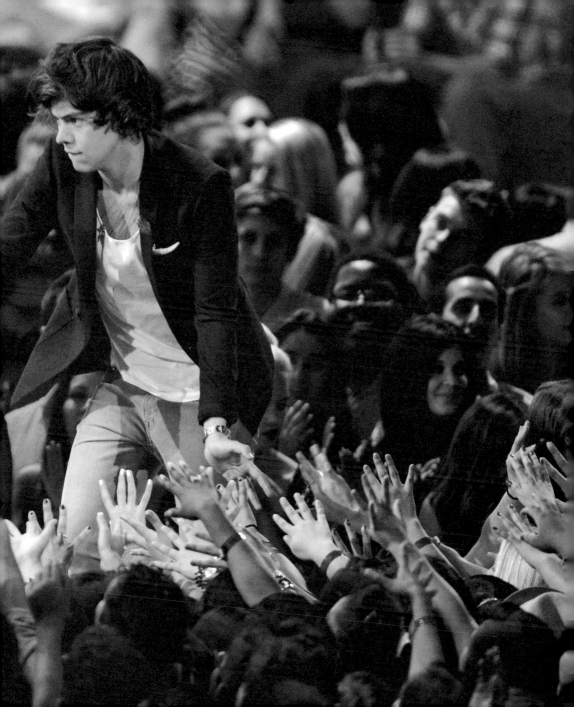

"THAT'S THE AMAZING THING ABOUT MUSIC:

THERE'S A SONG FOR EVERY EMOTION."

TAYLOR SWIFT

On 1st April, 2012, Harry tweeted: "I met some amazing people today. And had a lot of fun." He certainly did — this was the day Harry met Taylor Swift, after she watched One Direction perform "What Makes You Beautiful" on the Kids' Choice Awards. Things moved fast: they hung out at Justin Bieber's pool party a few days later.

Mix-ups involving exclusivity sadly ensued and when Harry was papped kissing a model, the relationship was over before it even started. But in October, hope bloomed. They were in the same place at last, ready to begin again. After Taylor's rehearsal for the American version of *The X Factor*, Harry was spotted throwing her over his shoulder and carrying her, giggling, to her trailer.

On 2nd December, Harry and Taylor were photographed by paparazzi in New York's Central Park (right). In celebrity language, this means becoming official (a red carpet appearance is the equivalent of marriage). "Haylor" was here. They managed to find time for each other for the rest of the year and flew out to the British Virgin Islands for a romantic New Year's getaway. Drama struck on January 4th, however, and after some kind of argument Taylor was seen alone, on a boat, travelling back to the States.

Haylor was here for a good time, not a long time, but it did give us some fantastic music. Taylor wrote several songs about Harry, including, of course, "Style". Harry has been nothing but lovely about it: "I don't know if [the songs are] about me or not, but the issue is, she's so good, they're bloody everywhere." Ever the gentleman, Harry has been respectfully tight-lipped about whether any of his own songs are about her.

At the 2023 Grammy awards, Taylor and Harry were seen interacting publicly for the first time in a decade, when she congratulated him on his award for Album of the Year. It seems that while the love affair was a rollercoaster at the time, there are no hard feelings.

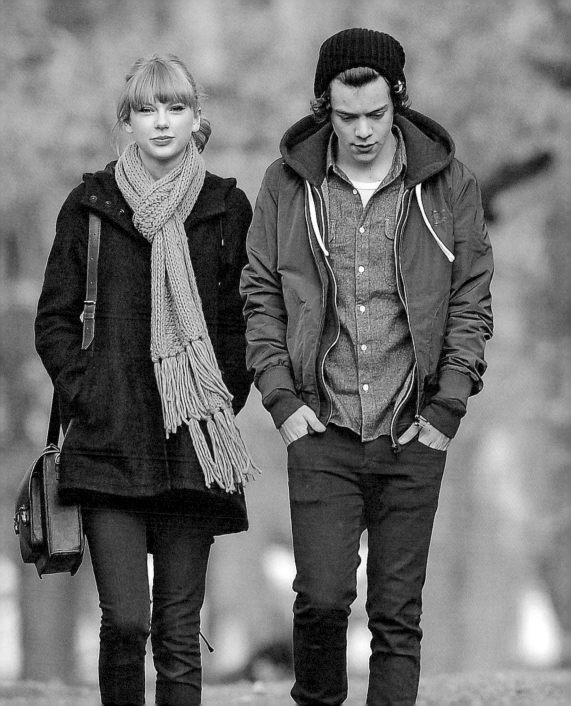

ONE DIRECTION: THIS IS US

The documentary *One Direction: This is Us* followed the band as they toured their second album *Take Me Home*. We learn the boys' backstories, such as how Harry started performing by singing into the mirror, miming to his older sister's pop songs. There are highs (playing London's O2 arena) and lows (Niall wheels Harry around in a bin). The backstage banter is endless, as the boys battle boredom with pranks and endless games of football in the bland corridors of music venues. It's obvious that the team around them have a lot of work keeping these five boisterous young men focused on the task of being in a boyband.

Harry already seems to be differentiating himself from the rest of the band. One of the wardrobe team dresses him in a trenchcoat and scarf, then stands back, slightly awed by the transformation from puppyish boy to stylish man. She says he looks just like an advert, and he does. It's not just the looks or charisma; it's the attitude. Harry's bandmate Zayn tells the camera crew that Harry was "born" to be a popstar. Aside from being nagged to put his clothes on and get to the stage, he also seems professional and committed to giving a good performance at all times.

This determination is admirable but tiring. The band plays sold-out shows, night after night, and records vocals for their next album in hotel rooms whenever they can — no gorgeous recording studios or lengthy writing sessions for them. At least being part of a band rather than a solo artist meant Harry always had mates who understood what he was going through. In later years, he has said: "I feel really lucky that we always had each other to be this unit that felt like we could keep each other in check and you could just have someone else who gets it."

For the premiere of the documentary, Harry hinted at the Styles style journey ahead, wearing a Burberry heart-print shirt. Maybe he was auditioning for that trenchcoat advert!

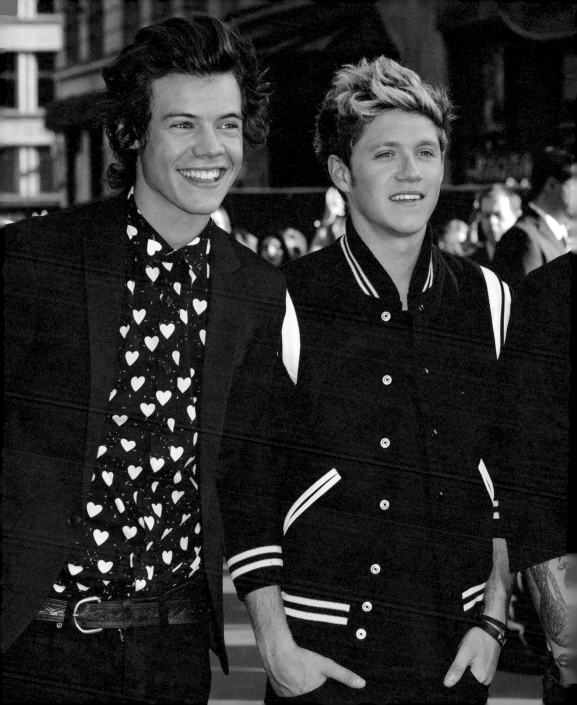

ON THE ROAD AGAIN TOUR

The *On the Road Again* tour is famous for two turning points in One Direction history. Firstly, this is the era of Harry's long hair. When the tour began in February 2015, the hair was just starting to hit his shoulders. By May, Harry had cascading ripples of hair like a mermaid's. Was it a rebellion against the boyband look, to go with the quirkier fashion sense he was developing?

One person in One Direction who was definitely not happy with the pressures and constraints of boyband life was Zayn. Frustrated with the band's poppy sound, reeling from tabloid scandals and suffering from anxiety, he began leaving the stage during concerts, unable to go on. Eventually, he decided he couldn't continue. The band's concert in Hong Kong was the last time he would perform with the other four boys. On 25th March 2015, the band revealed that Zayn had quit. He told the press, "I am leaving because I want to be a normal 22-year-old who is able to relax and have some private time out of the spotlight. I know I have four friends for life in Louis, Liam, Harry and Niall. I know they will continue to be the best band in the world."

Harry was shocked, although he and his band members avoided questions about Zayn as much as they could. In 2020, Harry told Zane Lowe, "We were sad that someone had left. But also sad that he was not enjoying it so much that he had to leave."

The band still had all their Africa, Europe and North America dates to go. Rather than act like Zayn had never existed, they left a space for him in their onstage formations, like the nice boys they are. After 80 shows, they must have been exhausted! Time for a break, surely...

After their final show on 31st October 2015, they had exactly two weeks until the launch of their fifth album, *Made in the A.M.*

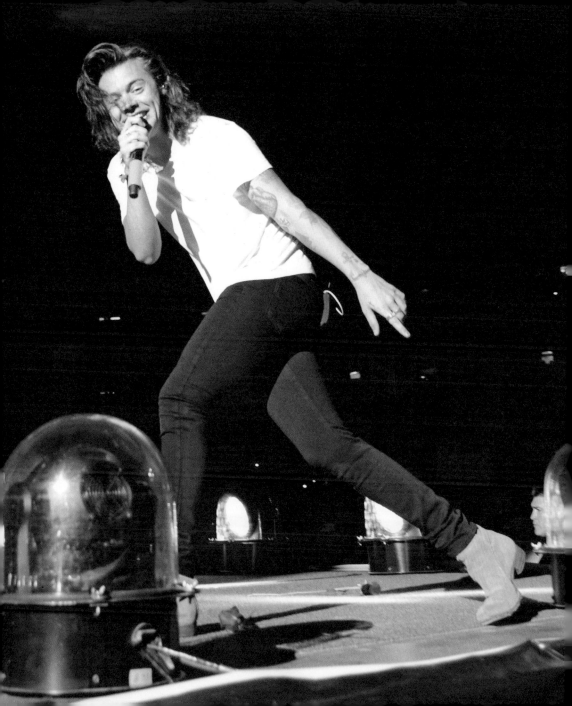

"IT'S A LITTLE NAÏVE TO JUST WRITE OFF YOUNGER FEMALE FANS..."

YOUNG GIRLS WERE MASSIVE FANS OF THE BEATLES. IT'S CRAZY TO THINK THAT THEY'RE NOT INTELLIGENT."

THE LATE LATE SHOW

In the middle of the intense *On the Road Again* touring schedule, One Direction appeared as guests on James Corden's TV show *The Late Late Show*. This was their first media appearance since Zayn left, and questions about the drama were inevitable. Harry says roughly one word throughout this awkward section, letting the other boys handle the smooth denials of any resentment towards their ex-bandmate.

Harry was much happier when they got on to the fun and games. He and James Corden have been friends since *The X Factor* days. James relished the chance to tease Harry on everything from his clean-living ways (suggesting he spent his nights on tour reading a self-help book in his hotel room) to his many tattoos. By this time, Harry had dozens of tattoos scattered over his body, including a mermaid, which he explained by saying: "I am a mermaid." Referring

to his classic tattoos of swallows, ships and anchors, "I like that kind of style of tattoos, like the old sailor kind of tattoos. They symbolise traveling, and we travel a lot." During their chat, Harry admitted to James that he has a tattoo of the word "big" on his big toe.

The games portion of the show was dodgeball, with 1D on James's team, "Corden's Angels". They were dressed in red and white, which James suggested made them look like they were in *High School Musical*. Harry gets surprisingly competitive, but the Angels lose out to the opposing team. The real winner, however, is Harry's stylist.

Harry Lambert is a British fashion stylist who Harry (Styles) has been working with since 2014. He has played a key part in turning the cute kid into the fully-fledged adult fashion icon we know and love today. Turn the page to see 1D in their sports kit and pay attention to the intentional details of Harry's outfit. Unlike the other boys, who have thrown on their shorts and vests in a very typical lad way, Harry has picked the short shorts — because of course he has — and somehow cropped the vest and given it a higher neck.

When 1D returned to *The Late Late Show* in December 2015 to promote their new album *Made in the A.M.*, Harry's relaxed attitude to needles and ink was helpful. Each of the boys, and James, got a big red box. Inside four of the boxes was the word SAFE and inside one was the word TATTOO. Whoever opened their box and found TATTOO inside had to get one, right there on the show. As each of them opened their box, Niall was visibly sweating. Liam and Louis opened their boxes to reveal the word SAFE. James opened his box to find he was SAFE. It was down to Harry, and Niall. Niall had zero tattoos and he was clearly dreading the prospect of either getting one or crying in front of the nation. He was so stressed out that Harry gave him a hug to calm him down. The lights dimmed, the tense music played, and Harry opened his box, which said... TATTOO.

A jubilant Niall punched the air. Harry sat down and had the show's logo tattooed on his left arm, between a heart and the words "You booze you lose". James thanked him for being "an incredible sport". You have to hand it to Styles — he absolutely lives for the moment.

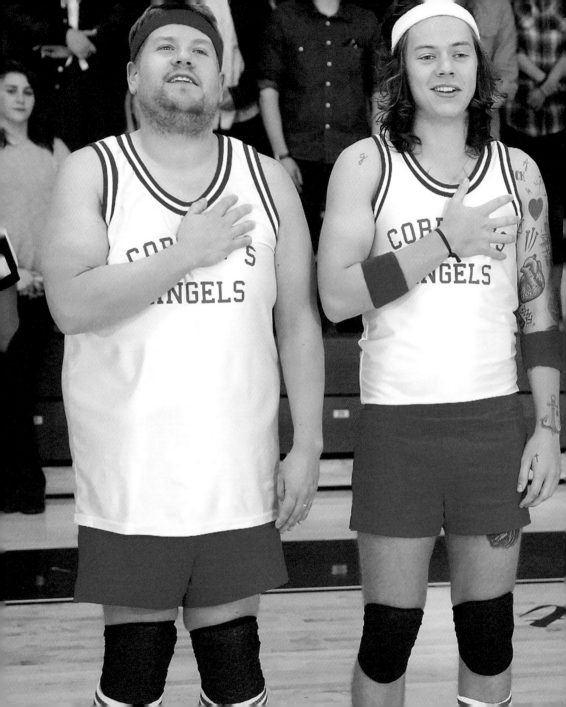

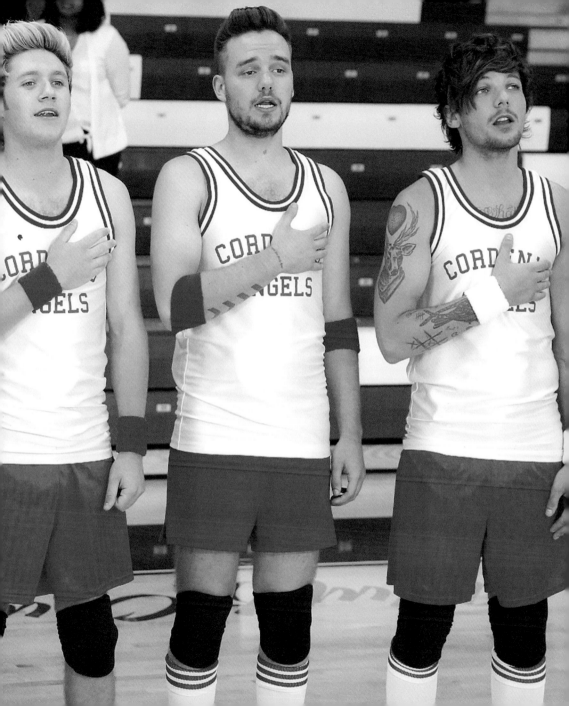

AMERICAN MUSIC AWARDS

This was the moment that the world sat up and took notice of Harry's fashion sense. Standing next to Liam, Louis and Niall, all dressed in smart but sober suits, Harry took to the red carpet of the American Music Awards. He was wearing an outfit that was considered outrageous at the time, a flared floral suit from Gucci's next collection. This went against every rule of getting dressed in 2015: trouser legs were skinny, suits were plain, and men dressed in black, grey or blue. Flowers were out of the question.

The media snickered at his outfit, saying it looked like a grandma's bedspread. A) Give some respect to grandmas and B) He looks great. Clearly Harry had the last laugh, as his bold statement heralded a more maximalist era in fashion and was the first of many Gucci suits he would go on to wear.

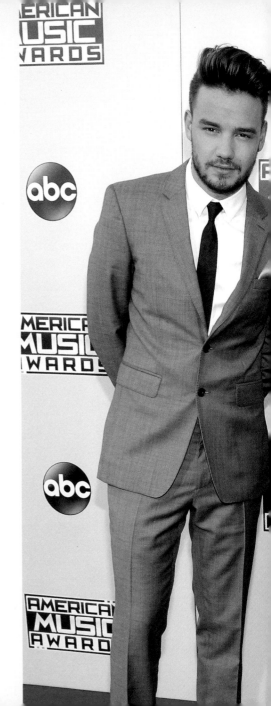

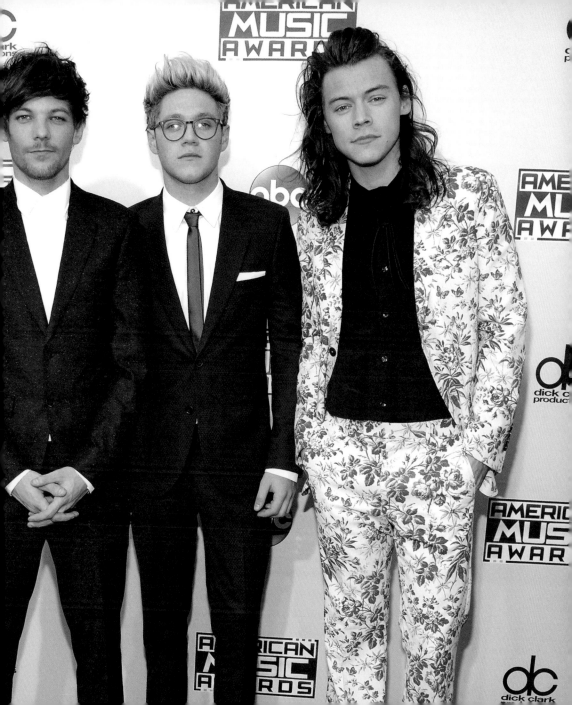

FIRST SOLO ALBUM LAUNCH

Harry had been in the spotlight ever since he was 16. After the band went on indefinite hiatus, it was time for a break, to live his life away from the cameras, and contemplate a potential solo career. According to Harry, he also needed to work out who he was outside of a band: "It was probably time for me to have to make some decisions for myself and not be able to hide behind anyone else. As a person, too, probably. Everything, workwise, that I'd done since I was 16 was made in a democracy."

Figuring out a musical direction wasn't easy. Although One Direction's music had moved towards a rockier sound for their later albums, with songs like "Drag Me Down", everything about 1D was a unique case in music. All the other solo stars were doing either pure pop or hip-hop. Rather than trying to chase hits by copying the sound of the moment, Harry decided, in a very Harry way, to just do what felt good. He said: "I really wanted to make an album that I wanted to listen to. That was the only way I knew I wouldn't look back on it and regret it. It was more, 'What do I want to sit and listen to?' rather than, 'How do I shake up compared to what's on radio right now?'"

Harry's debut solo record, *Harry Styles*, came out in 2017. The first single, "Sign of the Times", was a smash, going number 1 in the UK and reaching number 4 on the US Billboard Hot 100. Even better, the album went number 1 on both sides of the ocean, becoming the ninth-best selling album of the year worldwide.

The album lured in a lot of new fans who had never really listened to 1D. The reward for longtime fans was seeing a few new sides to Harry. There's the brazen rockstar on "Kiwi", which is full of innuendo. And there's the wistful, poetic side to him. Harry explained: "'Two Ghosts' I wrote for the band, for *Made in the A.M.* But the story was just a bit too personal." Fans have speculated about the person with red lips and blue eyes who Harry sang about, but I guess we'll never know.

THE TODAY SHOW

Harry Styles was out in the world and it was time for him to put himself back in the spotlight. A live performance at *Today* was the perfect stage. The flamingo-pink suit was a good sign that Harry was ready to express himself authentically through fashion. But what the world wasn't expecting was how incredible Harry's voice sounded. "Sign of the Times" showcased his falsetto and mellow vocal tone.

As for the suit, it was meant as a statement. The album's working title was *Pink* for a while, inspired by a quote from The Clash's Paul Simonon: "Pink is the only true rock & roll colour." The suit was made by Edward Sexton, a British tailor who made wedding suits for both Bianca Jagger and Mark Ronson. It was a huge nod to rock'n'roll and Harry's British heritage.

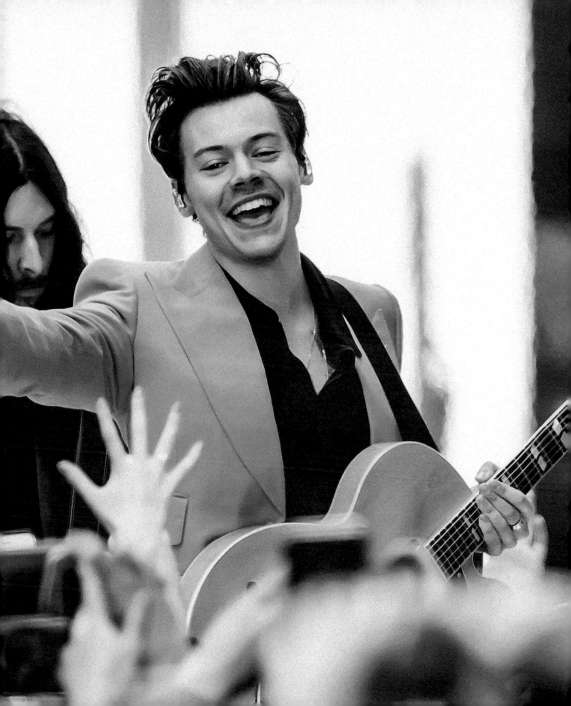

"YOU GET MOMENTS ALL THE TIME..

THAT KIND OF MAKE YOU PINCH YOURSELF."

DUNKIRK PREMIERE

The film director Christopher Nolan is renowned for his gritty, complex film-making on movies, like the brilliant and infinitely rewatchable *Inception*. In 2016, he made the war drama *Dunkirk*, about an event in World War II where soldiers had to be rescued by civilian boats. Along with his favourite actor Cillian Murphy (who later played the title character in *Oppenheimer*), Nolan decided to cast a newcomer named Harry Styles as the young soldier Alex.

Nolan says Harry was cast just like any actor would be: "Harry sent in a tape, and we liked the tape. And he joined the workshop, and that was that. It was a really old-fashioned process – and Harry's features, ability and demeanour fitted right in. [...] Harry shied away from being a 'star' in it. He's a humble guy who didn't want attention."

The story follows a soldier called Tommy, played by Fionn Whitehead, who rescues Alex from the waves. Together they desperately try to board a ship back to England, to escape the oncoming German army. Constant attacks put them in peril throughout the movie. Harry gets to play against type as someone with a xenophobic grudge against a French soldier. Harry described Alex as "a young soldier who didn't really know what he was doing", adding, "The scale of the movie was so big that I was a tiny piece of the puzzle. It was definitely humbling. I just loved being outside of my comfort zone." The shoot was gruelling as, due to the nature of the story, Harry spent most of his time in the water. "It was hard, man physically really tough, but I love acting. I love playing someone else."

For the movie's premiere, Harry wore a plain navy suit and took his mum, Anne, for moral support. The film was a success, becoming the highest-grossing World War II movie until *Oppenheimer* and launching Harry's acting career.

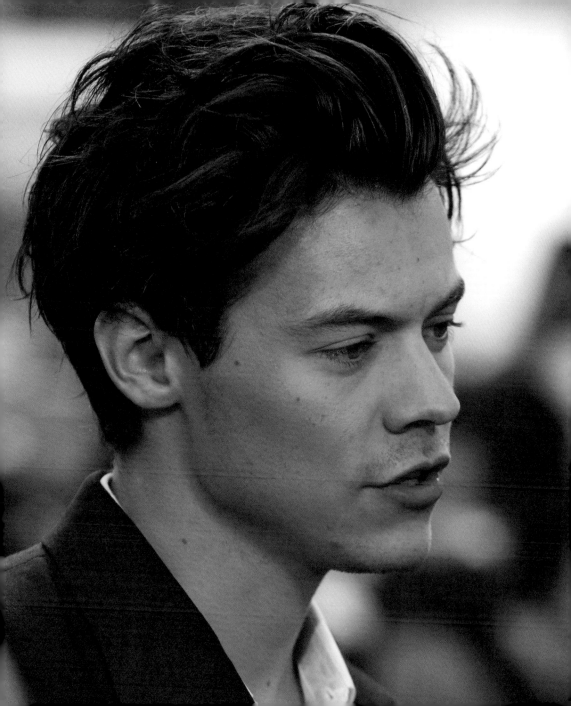

MADISON SQUARE GARDEN

Harry played New York City's 20,000-capacity Madison Square Garden with One Direction for the first time in 2012, and came back for a triumphant solo show in 2018. It's easy to forget that although he remained one of the world's most famous people, he had to work hard to build his solo music career. The love from his fans helped evaporate his nervousness: "The tour, that affected me deeply. It really changed me emotionally. Having people come to sing the songs. For me the tour was the biggest thing in terms of being more accepting of myself." This was another moment where Harry stepped into the light, so it was apt that he chose to wear a bell-bottom Gucci suit with a slight resemblance to the one he wore at the AMAs.

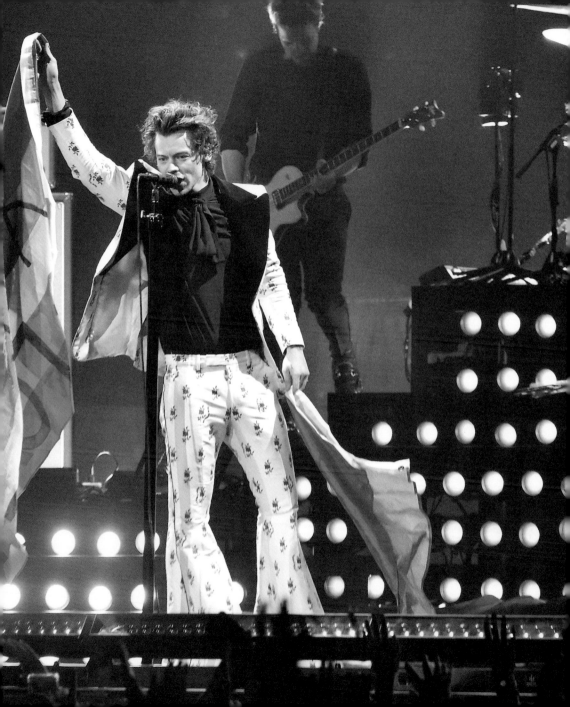

ELTON JOHN

Harry claims not to enjoy Hallowe'en: "Hallowe'en is not fun! I'm sorry. [...] you're like, 'Do people go for it, or do they not really go for it, or do we go for it?' And to really go for it, I need to plan it." This is the exact dilemma everyone faces on Hallowe'en every year!

For Hallowe'en 2018, Harry did the planning and went to a party in L.A. dressed as Elton John. The costume was a perfect replica of a sequinned baseball outfit Elton wore to play Dodgers Stadium in 1975. It was a nod to one of pop's most glittering performers, who Harry counts as an influence. Harry told *Vogue* that Elton and his many glitzy looks were an inspiration to him: "You can never be overdressed. There's no such thing. The people that I looked up to in music — Prince and David Bowie and Elvis and Freddie Mercury and Elton John — they're such showmen."

Seeing 1970s rockers like Elton mix what was perceived as feminine and masculine was obviously a huge influence on the younger Harry: "As a kid it was completely mind-blowing. Now I'll put on something that feels really flamboyant, and I don't feel crazy wearing it. I think if you get something that you feel amazing in, it's like a superhero outfit. [...] When you take away 'There's clothes for men and there's clothes for women,' once you remove any barriers, obviously you open up the arena in which you can play."

Elton loved Harry's look and posted on Instagram to say: "Now that's what I call a Hallowe'en costume." Elton is known for collaborating with younger stars like Dua Lipa and Britney Spears — in fact, the cover of their duet "Hold Me Closer" featured Britney in a leotard version of the very same Dodgers uniform. When asked if Harry could be his next collaborator, Elton said: "That would be amazing".

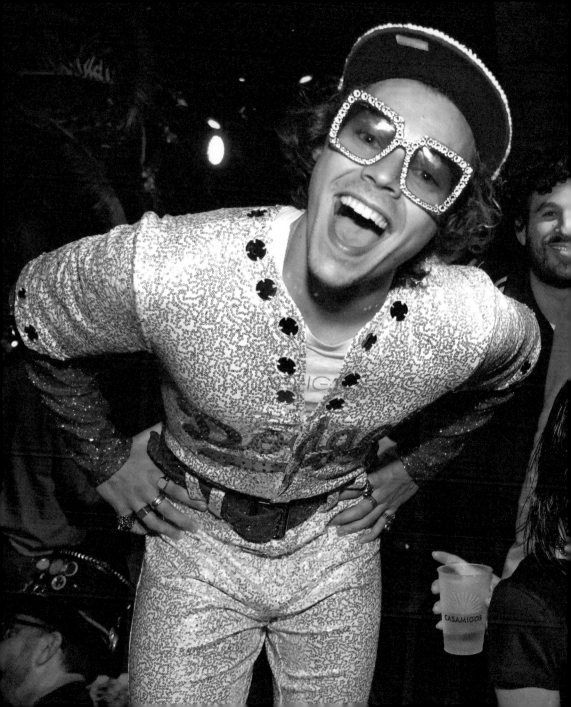

ROCK & ROLL HALL OF FAME

Harry has plenty of famous friends — his UK-based friends include Alexa Chung, Rita Ora and Ed Sheeran, and he goes on holiday with Adele. In the States, he has been pictured hanging out with Cindy Crawford and Kaia Gerber at the beach and his 21st birthday party was attended by David Beckham and Chris Martin from Coldplay.

Harry's gift for friendship is especially obvious in his connection with a peak music legend, mysterious witch-like figure, and the inspiration for *Daisy Jones and the Six*. Stevie Nicks was part of the 1970s group Fleetwood Mac, notorious for falling in love, breaking up and then putting it all in their music. Their album *Rumours* is one of the best records of all time and sounds just as good in the 2020s as it ever did. Harry went to a Fleetwood Mac concert in 2015

just like any fan. Unlike an ordinary fan, he was allowed backstage, where he gave Stevie a carrot cake: "Piped her name onto it. She loved it. Glad she liked carrot cake." Those smooth Styles moves!

Stevie was obviously very charmed by this behaviour, as you would be. They became friends, with Stevie calling him "the son I never had". When Harry's debut solo album came out, she said: "I love Harry, and I'm so happy Harry made a rock & roll record — he could have made a pop record and that would have been the easy way for him. But I guess he decided he wanted to be born in 1948, too — he made a record that was more like 1975." Harry is clearly an "old soul", someone who thinks about thinks deeply. That's the guy that James Corden said would be more likely to read a self-help book than play video games on the tour bus. It says a lot about him that he has friends across generations, and can gain the respect of someone like Stevie Nicks.

Stevie is the first woman to be inducted into the Rock & Roll Hall of Fame *twice* (she has since been joined by Carole King and Tina Turner). The Rock Hall is basically a private museum that

publishes a list of people who have
had a huge impact on rock music. It's
considered an honour to be included and
each year a select handful of musicians
and songwriters are added, or "inducted".

In 2019, Stevie was inducted into the
Hall of Fame for her solo career. Harry
introduced her and gave a beautiful
speech about the impact her music has
had on him: "Dreams" was the first song
I knew all the words to before I knew
what the words really meant." Speaking
of Stevie as a person, he described her
as "the magical gypsy godmother who
occupies the in-between. It's a space
that can only be hers. She's a lot like
a rock'n'roll Nina Simone, finding the
notes only she can. And by being so
unapologetically herself, she gives others
permission to do the same". If Harry has
one central mission, it's to be himself
and encourage others to be themselves.
Clearly, in Stevie Nicks, he has found a
kindred spirit.

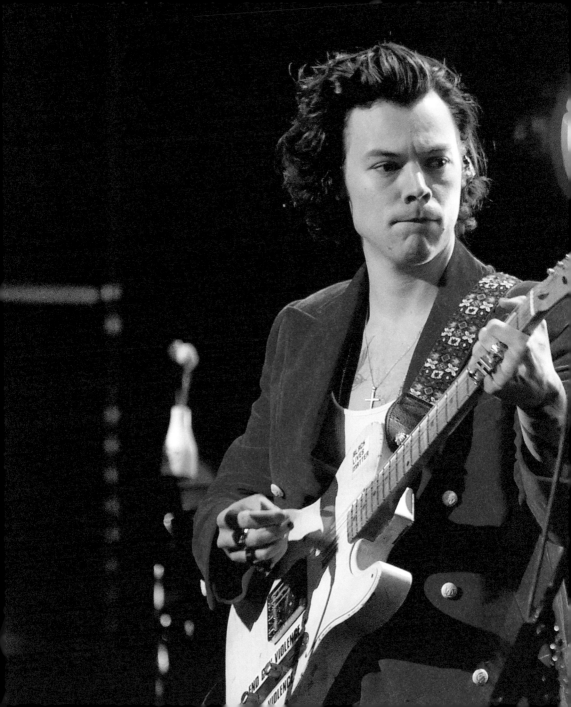

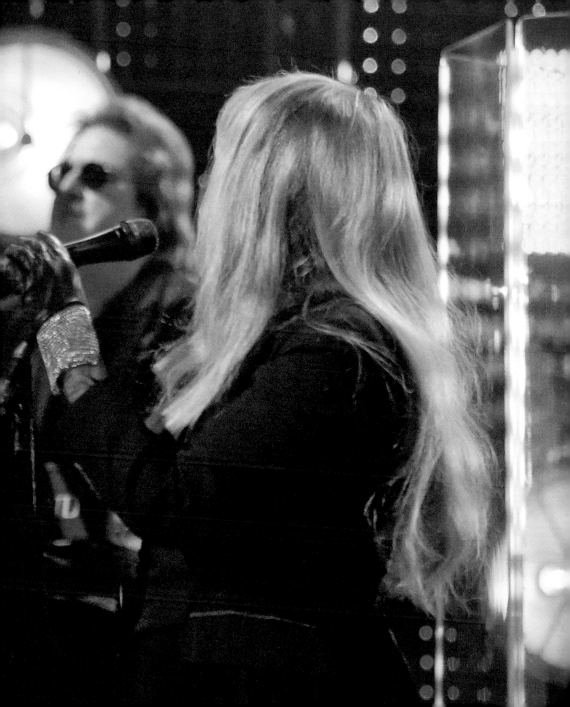

The theme of the 2019 Met Gala was "Notes on Camp" inspired by an essay by the famous writer Susan Sontag. The Met Gala is the highlight of the fashion year because the celebrities always turn out wearing outfits that are strange and intriguing, rather than just designed to make them look hot. The theme is a challenge for many of them, which must be why Harry was spotted holding a copy of Sontag's book — he wasn't going to risk misunderstanding the idea of "camp", not when he was actually hosting the Met Gala!

Co-chairing the event means helping to organise it, deciding what food will be served and even who gets to come. It goes without saying that the co-chairs must appear on the red — or in this case, pink — carpet looking incredible. Harry wore a transparent, black Gucci ensemble with lace sleeves and a big flowing ribbon at the neck.

Harry's stylist told *Vogue*: "This look is about taking traditionally feminine elements like the frills, heeled boots, sheer fabric and the pearl earring, but then rephrasing them as masculine pieces set against the high-waisted tailored trousers and his tattoos." Harry said that, to him, camp "is about enjoyment, about fun, no judgement, having fun with clothes — I think fashion is supposed to be fun. I think it's a good time for that right now: people being who they are."

The high-waisted trousers were a hint of things to come for the next album era. The finishing touch was a dangling pearl earring, which seemed to reference both 1990s singer George Michael's signature earring and Vermeer's painting *Girl With a Pearl Earring*. If "camp" is all about taking a look to the next level and layering in many knowing winks, then Harry smashed it out of the park. If it's about looking extremely gorgeous and dapper, he also fulfilled this brief.

For the formal dinner part of the evening, Harry changed into a white shirt with billowing sleeves, and an oversized, asymmetric bow in red silk. Once all the hosting was done, it was time to relax, dancing to music provided by Cher and Mark Ronson.

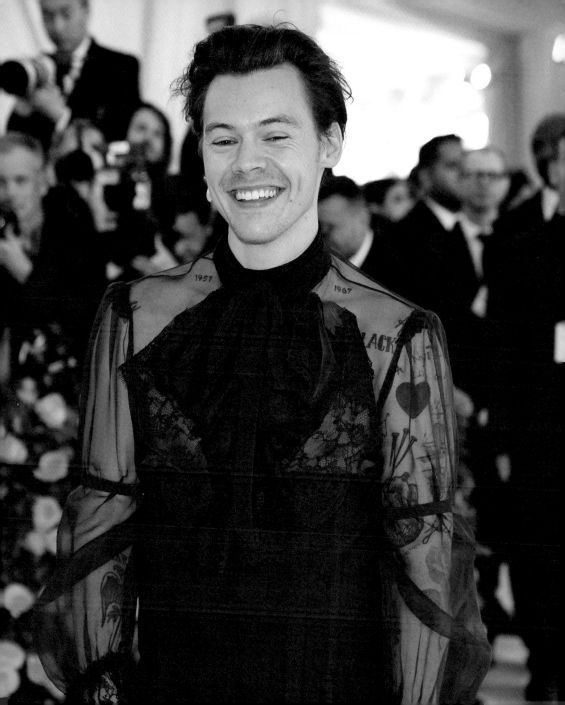

"THERE'S A LOT OF THINGS THAT COME WITH THE LIFE YOU COULD GET LOST IN

BUT YOU HAVE TO LET IT BE WHAT IT IS. I'VE LEARNED NOT TO TAKE EVERYTHING TOO SERIOUSLY."

THE LATE LATE SHOW WITH KENDALL JENNER

Harry just couldn't stay away from *The Late Late Show*. In May 2017 he sang tracks from his new album *Harry Styles* every night for a week. He also recorded an episode of "Carpool Karaoke", a skit where James Corden drove around LA having a sing-a-long with a celebrity guest. In Harry's episode, we learned what his favourite movie is: "*The Notebook*. I feel like I should say my favourite movie is like *Fight Club* or something but it's just not."

In December 2017, James was attending the birth of his baby, who Harry explained had been born just half an hour before the show began taping.

Harry is a good friend — he got called in at the last minute to fill in and he leapt into action even though "I have to be honest, this is not exactly how I saw my day panning out."

In 2019, Corden was working on a film. It was time for Harry to step in again and this time, with a little more notice, he had the brilliant idea of inviting Kendall Jenner, one of the Kardashian media dynasty, onto the show. Harry and Kendall have known each other for a long time and were rumoured to have dated on and off over the years. Harry, who is always a closed book on the topic of his dating life ("I like to separate my personal life and work. It helps, I think, for me to compartmentalise"), refused to confirm the rumours. The most confirmation the public ever received were some long-range paparazzi shots taken of the two of them cuddling on a yacht in 2015.

Regardless of their romantic history, the pair seemed to be perfectly friendly by 2019. Kendall and Harry played a game live on air called "Spill Your Guts or Fill Your Guts". They sat at a table covered in dishes of items that were technically edible but would be a challenge to eat,

ke bug trifle and bull penis. Taking turns,
hey had to decide whether to answer
 queston truthfully, or eat one of the
ems in front of them.

endall seized her opportunity. She
hade Harry choose between eating
od sperm and answering the question
Which songs on your last album were
bout me?" She said she was "dying to
now this". Given how closely we look at
arry's lyrics to try and figure out what
hey mean, Kendall spoke for us all. After
esitating for a while, Harry chose the
od sperm.

inally, Kendall pointed to an enormous
ug called a water scorpion. She started:
Between Louis, Liam, Niall and Zayn, rank
heir solo" — Harry grabbed the insect
nd munched it right down. That's right
arry, it's not a competition. From "Back
o You" (Louis) to "San Francisco" (Niall),
om "Pillowtalk" (Zayn) to "Naughty
ist" (Liam), the other four boys have
heir own solo songs to be proud of.
owever, Harry is about to release
omething very special.

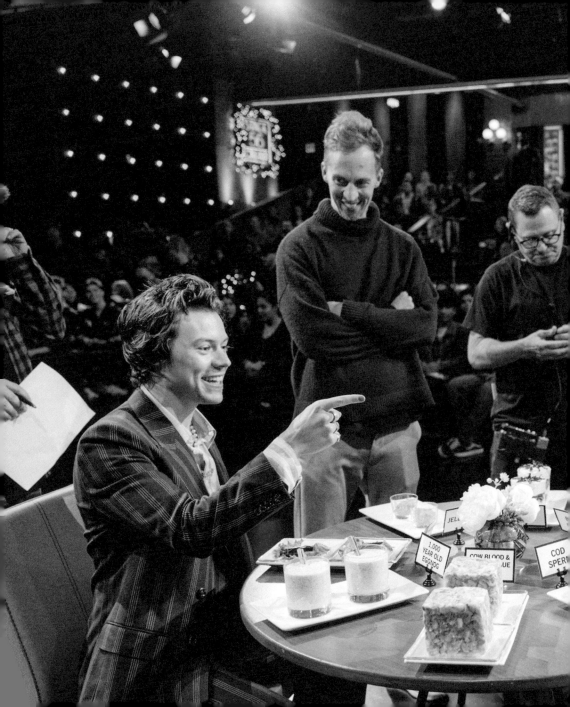

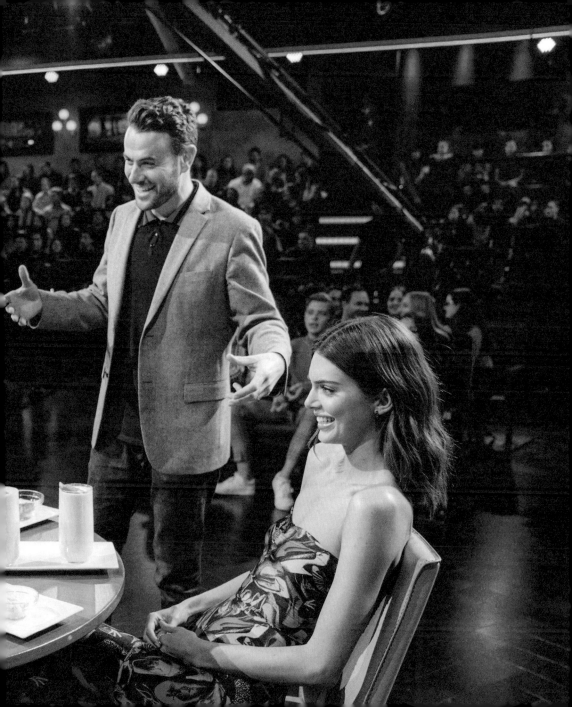

FINE LINE LAUNCH

The launch for Harry's second solo album was intriguing. It began with mysterious posts on social media inviting people to book a holiday in Eroda. Fans quickly figured out Eroda is "Adore" backwards, a reference to the song "Adore You". On 6th December 2019, the video to "Adore You" was released. Through the story of his love for a magic goldfish, we saw a new, quirky side to Harry. On 13th December the album was finally released and we entered the sparkly and fruit-filled *Fine Line* era.

The album was a revelation in terms of overall sound and standout tracks. Although they still felt organic and intimate, the songs were catchier than on the rocky debut album, and seemed to tap into deeper emotions. Harry was liberated, and finally felt like he could just have fun with his music: "This time I really felt so much less afraid to write fun pop songs. It had to do with the whole thing of being on tour and feeling accepted." Heartfelt thanks to everyone who made Harry feel so comfortable and loved!

The singles "Lights Up" and "Adore You" were yearning pop songs, while "Cherry" (and another fruity tune) kept the fruit theme going after "Kiwi" from the first album. The heart-wrenching ballad "Falling" showed a side to Harry we'd never really heard before: heartbreak over a lost love. The deep cuts on the album are some of Harry's best songs — the cheerful, strummy "Canyon Moon" references 1970s folk rock stars who lived in Laurel Canyon in California, artists like Joni Mitchell and Crosby Still Nash and Young. "Sunflower Vol.06" is about the little things that make you fall in love with someone, set over a bouncy, sunshine backing track.

Fine Line was a smash hit and also loved by the music establishment: after 10 years of making music, the album brought Harry his first Grammy nominations. More importantly, are those pearls Harry is wearing?

BRITS RED CARPET

Harry's look for the red carpet at the 2020 Brit Awards was the most significant since the black-and-white Gucci suit that confused people so much back in 2015. He was ready to re-ignite the conversation around clothing and gender!

Before we even get to the pearls, let's acknowledge the incredible colour combination going on here. A purple sweater under an aubergine suit, with just a peep of sky-blue shirt? It was new ground for formal menswear, which usually only came in black or navy blue; grey for the real show-offs. Harry's music often draws from the sounds of the 1960s and '70s, which was also the last time Western menswear was colourful and patterned.

Then there's the pearls, which sparked a major trend and became a signature part of Harry's look, as much a part of

his fashion legacy as artfully tousled curls and a wide-legged trouser. There's something about their soft shape and moon-like glow that feels feminine to people. Until very recently, pearls have been associated with posh older ladies, and there's an element of "granny chic" to this look that is so cute on Harry.

Harry performed "Falling" at the awards show, wearing a voluminous white lace jumpsuit. Hopefully he had a good time at the party because shortly after the event, promotion for *Fine Line* and life in general screeched to a halt due to the Covid-19 pandemic. An unintended consequence of global lockdown was that people spent a lot of time listening to music as a way to break up the monotony. *Fine Line* was the perfect comforting listen for tough times and grew to be a beloved album and modern classic. It even made *Rolling Stone* magazine's top 500 Greatest Albums of All Time in 2020.

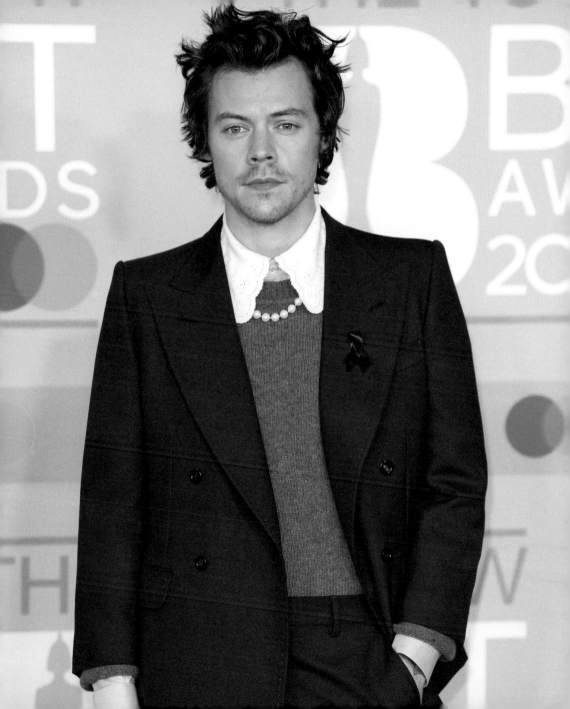

GRAMMYS WIN

Anticipation was high for what Harry would wear to the 2021 Grammys. It was his best shot yet at getting a golden gramophone trophy. He was also due to perform as the night's opening act. Basically, all eyes were on him.

Harry took to the stage wearing a black leather suit and an acid-green faux fur boa. He seemed nervous at the beginning of his performance. As the song went on though, he loosened up. By the time he threw off the boa and started to dance during a jazz breakdown, he was grinning with pleasure. So was the audience because it turned out Harry had decided to go shirtless. He wears it well! Harry even did a choreography sequence with the backing singers.

All the effort paid off: Harry won his first Grammy, for Best Pop Vocal Performance. A career, and hotness, peak had been reached.

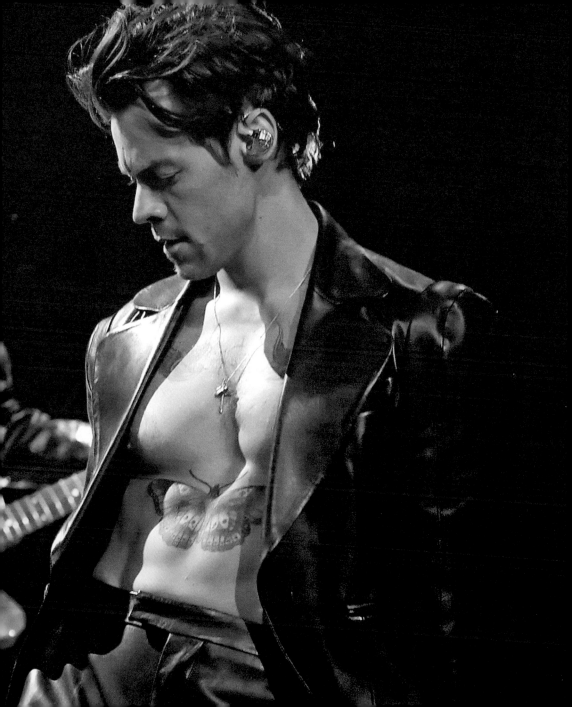

"IF YOU'RE HAPPY DOING WHAT YOU'RE DOING....

THEN NOBODY CAN TELL YOU YOU'RE NOT SUCCESSFUL."

WATERMELON SUGAR BRITS WIN

At the 2021 Brit Awards, Harry was awarded British Single of the Year for "Watermelon Sugar", beating other big songs of the year like Dua Lipa's "Physical". Along with his Grammy, this was a great haul for a song about fruit.

Let's unpack the "Watermelon Sugar" phenomenon. It's hard to imagine now, but it wasn't originally destined to be a single, but sheer fan love and sticking power turned it into one of the most popular songs of summer 2020. It's now virtually Harry's theme tune, as it encapsulates him as a popstar: it's sexy but in a sweet and wholesome way, and all it asks of you is to have fun.

The "Watermelon Sugar" video opened with the words: "This video is dedicated to touching." This was a nod to the millions of people feeling lonely and in need of a hug in May 2020. The video was fun and colourful, with Harry and a bunch of gorgeous people having fun on a beach eating fruit and frolicking.

The models say they had a great time on the beach with Harry. Aalany McMahan called the video "one of the most natural shoots I've ever been on". Another model named Ephrata called Harry the "consent king", saying he asked for permission to touch her: "I was taken aback for just a second and was like, 'Wow, he really cares if I'm comfortable. He cares if the other models are comfortable.'" Apparently Harry treats everyone with kindness: Ephrata also said: "He came and shook everybody's hand and gave us hugs and was like, 'Hi, I'm Harry.'" Not every celebrity takes the time to be polite the way Harry does.

Harry has been asked many times what the song is about and in reality this sweet, simple song probably wasn't about anything when it was written. On NPR's Tiny Desk Concert series, he said that "Watermelon Sugar" was about "that initial, I guess, *euphoria* of when

you start seeing someone or sleeping with someone or just like being around someone and you have that kind of excitement about them". Apparently he and his fellow songwriters had come up with the catchy tune and there was a copy of a book called *In Watermelon Sugar* in the studio that provided the inspiration for the title.

But when the song was released on *Fine Line*, fans quickly started to hear the saucy undertones. At one of his shows, Harry insisted: "This song is about — it doesn't really matter what it's about, It's about — it's about, uh, the sweetness of life." He acknowledged that there was another, more grown-up interpretation of the song, but as Harry loves to say onstage, "This is a family show."

The song's happy sound made it a standout on the album. It managed to reach number 17 on the UK chart and 54 on the US Billboard Hot 100 without a video or any promotion. When it was released as an official single, it became Harry's first number one song in America.

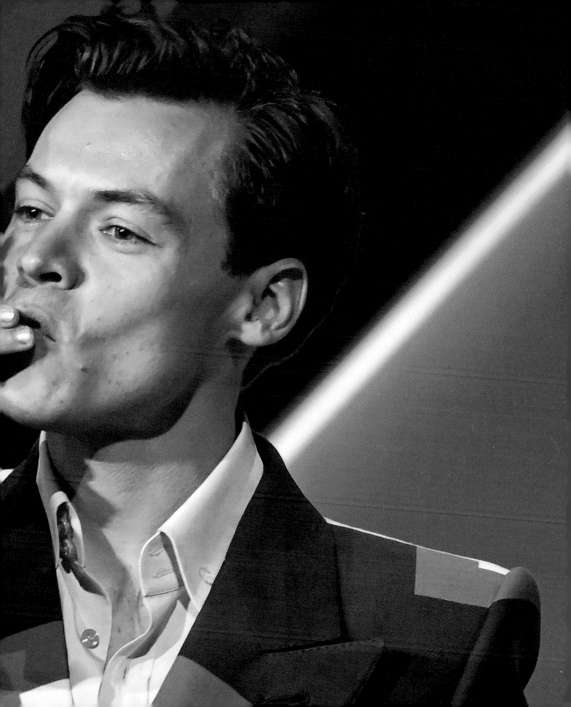

MY POLICEMAN

Harry's career as a leading man in movies started with an off-beat choice that prioritised character development over explosions. The British drama *My Policeman* (2022) starred Harry, Emma Corrin and David Dawson as three young people caught in a love triangle and ultimately torn apart by the old-fashioned, homophobic attitudes of the 1950s. It was based on the real-life story of the novelist EM Forster.

In May 2021, Harry was spotted filming a scene where he paddles in the sea in only his swimming trunks, which boded well for the movie. The final cut did have an extended scene of Harry swimming in slow motion, but overall it was more of a quiet domestic drama. The fundamental problem with it is how much time we spend on characters who aren't played by Harry. The movie's slow pace didn't excite the critics, but they did praise Harry's acting. *The Times* reviewer wrote,

"Harry Styles has the goods to be a movie star, and he's the best reason to see *My Policeman*." Other reviewers such as Deborah Ross at *The Spectator* praised Harry's love scenes with David Dawson: "The bottom is good. Ten out of ten for the bottom." This is not nothing! Actors act with their whole bodies after all.

Although *My Policeman* wasn't an unmitigated success, it was a great acting challenge for Harry to undertake. Playing a gay character was a brave choice that could have lost him some conservative fans. Clearly he felt it was an important story to tell. At the movie's premiere, he told the crowd: "The story's about wasted time, and that it's never too late to follow your heart and do what you want. I hope that people take that away from it. It's never too late to follow your happiness and be brave in love."

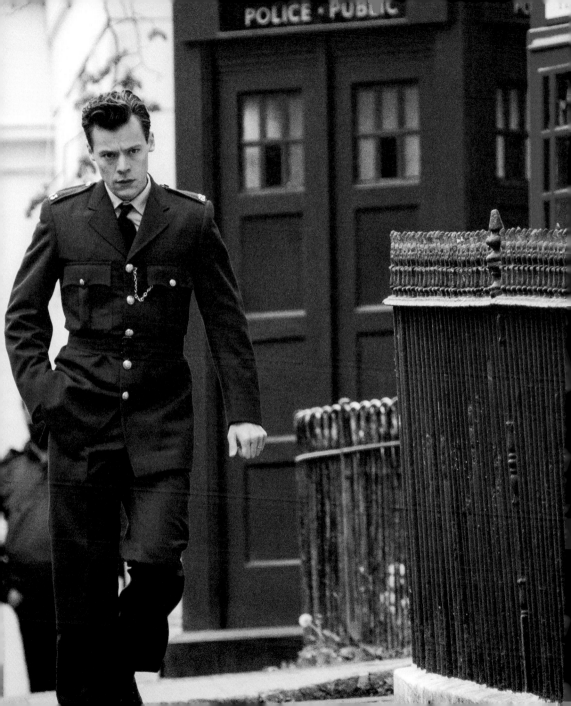

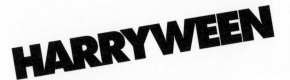

Over the Hallowe'en weekend of 2021, Harry was performing at Madison Square Garden again, midway through his *Love on Tour* concerts. Once again, Harry put the planning work in for the spooky season (see page 48). But why celebrate Hallowe'en when you could celebrate Harryween? For his 30th October *Love on Tour* concert, Harry dressed up as Dorothy from *The Wizard of Oz*, in a blue gingham dress and, of course, the ruby slippers. He even had a basket with a little toy dog in it, just like Toto from the movie. Harry's slippers were from Gucci rather than being stolen from a witch. He even showed off his vocal talent on the notoriously difficult song "Somewhere Over the Rainbow", nailing the full octave leap. It was a beautiful tribute to Judy Garland's iconic singing and acting in the role of Dorothy.

For his second night of the Hallowe'en weekend, 31st October, Harry chose an oversized clown outfit with a huge neck ruff and celestial symbols. The song he added to the setlist that night was "Toxic" by Britney Spears, which has become a modern spooky classic due to its references to poison.

The 2022 Harryween celebrations saw Harry's whole band wearing 1950s, *Grease*-inspired costumes. Harry dressed up as the movie's romantic lead Danny Zuko, with a black bouffant hairdo, while the female band members were the Pink Ladies in custom-pink jackets. Harry's costume included a leather jacket with "H ween" spelled out on the back in sparkly red crystals, plus a strawberry. The featured song was "Hopelessly Devoted to You", a tearjerker from *Grease*. In the movie it was sung by Olivia Newton-John, a beloved actor, singer and exercise influencer who had died a few months before the show.

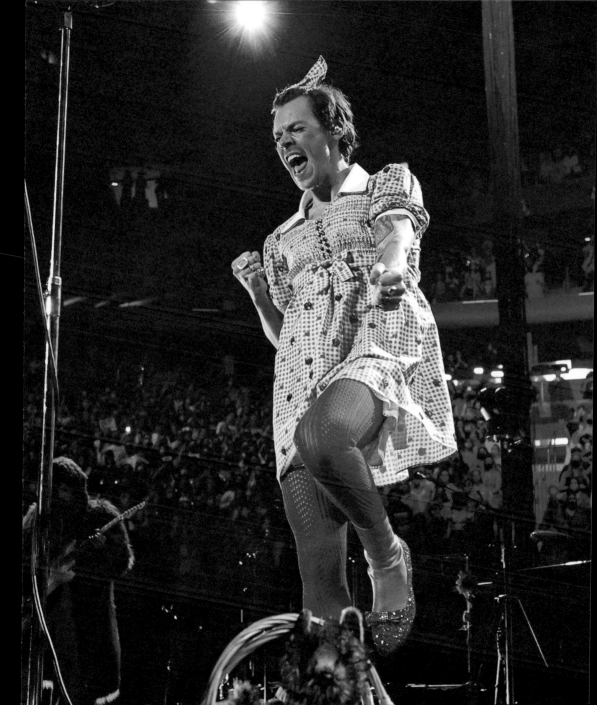

COACHELLA WITH SHANIA

For Harry's first appearance at Coachella, he clearly wanted to pull out all the stops and create a *moment*. Only one person would do for weekend one of the music festival, the woman who has had the biggest impact on Harry professionally: "My music and fashion main influence was always Shania Twain."

When Harry brought Shania out onstage, he told the crowd, "I have to tell you, [listening] in the car with my mother as a child, this lady taught me to sing." Possibly referencing her song about high standards, "That Don't Impress Me Much", he added "She also taught me that men are trash."

Harry and Shania's performance of her country-pop songs "You're Still the One" and "Man! I Feel Like a Woman!" was pretty explosive. They gazed into each other's eyes, and Shania ran her hand over Harry's rainbow sequins.

Shania revealed that she had met Harry when he was younger and he had begged her to call his mum, a big fan of Shania's clearly, to wish her a happy birthday. The perks of having a celebrity son! They had stayed in touch ever since and so Harry had her number when the time came to invite her to be his duet partner. Shania called it "one of the highlights of my career". Given what a Shania fanboy he is, Harry probably feels the same.

This week in 2022 was a truly magical one for Harry: it was the exact same week that his new song "As It Was" went to number 1 on the Billboard Chart.

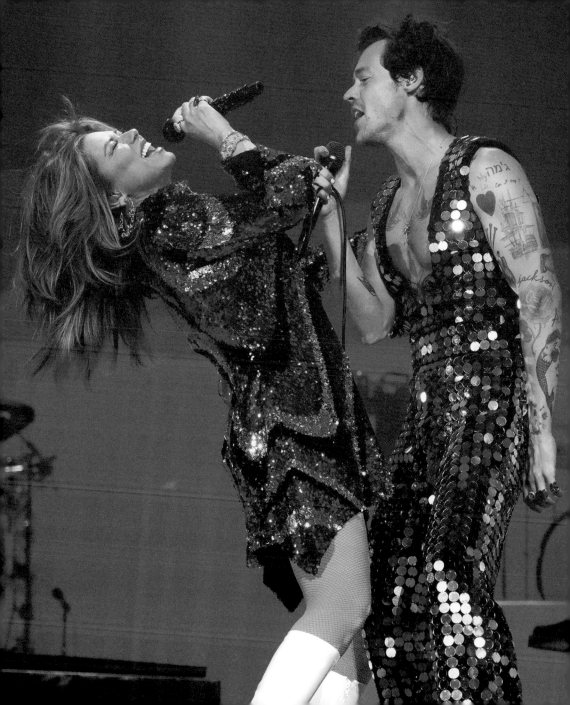

"I REALISED RELATIVELY EARLY ON THAT THE WHOLE...

'TRYING TO PLEASE EVERYONE' THING JUST DOESN'T WORK."

The second big Hollywood role Harry took on after *My Policeman* was playing an apparently perfect husband in the drama *Don't Worry Darling*. The film is a decent and original movie with a great cast, including Florence Pugh, Chris Pine and Gemma Chan. It critiques gender roles and incel culture against a bright and sparkling 1950s backdrop, in a similar way to *Barbie*, which came out the following year. In the words of film critic Harry Styles: "My favourite thing about the movie is, it feels like a movie". But let's face facts: the film itself has been completely overshadowed by the exceptional drama surrounding it.

The Venice Film Festival is an important fixture in the film-lovers' calendar. It's a great place to promote a new movie, providing a preview of the film for the kinds of people who vote for awards like the Oscars. Movie stars get to dress up in their best formal gear and the photos are sent round the world. The cast of *Don't Worry Darling* gathered for a group interview before the screening, but Florence was mysteriously absent. To understand why this might be, we need to rewind to the rumours that began emerging while the film was still in production.

The movie's director Olivia Wilde cast Harry after seeing his performance in *Dunkirk*, which "blew me away — the openness and commitment". Harry is always very cautious about revealing his love life to the media, after years of being called a "ladies' man" while he was in One Direction. But it became clear that he and Olivia Wilde were in a relationship when they were seen holding hands in January 2021, while the movie was still filming. Anonymous sources told the media that this love story had affected the atmosphere on the set of the movie, with Harry and Olivia spending their downtime in between takes together.

One thing that couldn't be denied was that the actor who Harry replaced on the film, Shia LaBeouf, did not take kindl to shade thrown at him by Olivia. He leaked a phone call between them where she seemed to condescend Florence, saying his departure from the film might

ct as a "a wake-up call for Miss Flo",
by which she meant Florence and Shia
might set aside their differences to get
the film made (he has been accused of
unprofessional behaviour on-set and
abuse towards his partners).

Florence did eventually arrive in Venice,
just in time to walk the red carpet with
the rest of the cast. Harry, who has still
not said a single word about any of this
drama, was there, wearing a dagger-
collared shirt under a midnight-blue
blazer. When they went into the cinema
to watch their movie, Harry was the
last to take his seat, between neutral
parties Gemma Chan and Chris Pine.
He appeared to dip his head towards
Chris, who stopped clapping and looked
down at his trousers. When this moment
hit the internet, it caused many people
to do muliple, slow-motion rewatches.
Did Harry really just spit on Chris Pine?
Chris Pine was clear on the matter:
"Harry did not spit on me. Harry's a
very, very kind guy."

The only person who seemed to
understand how funny the situation was,
was Harry. Back onstage for a gig, he told
the crowd, "I just popped very quickly to
Venice to spit on Chris Pine."

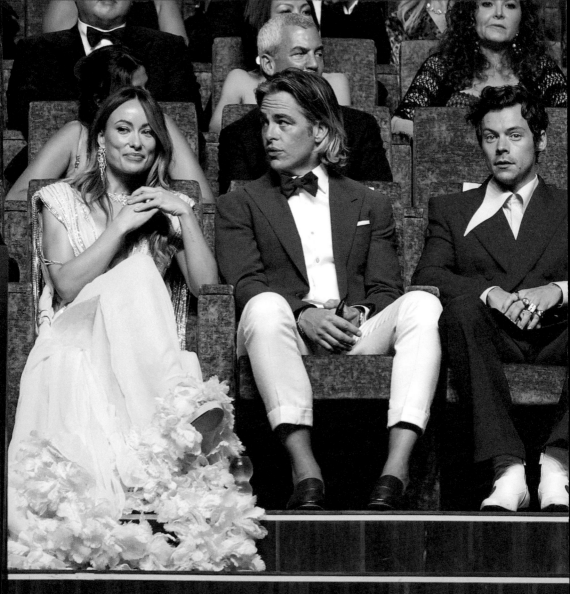

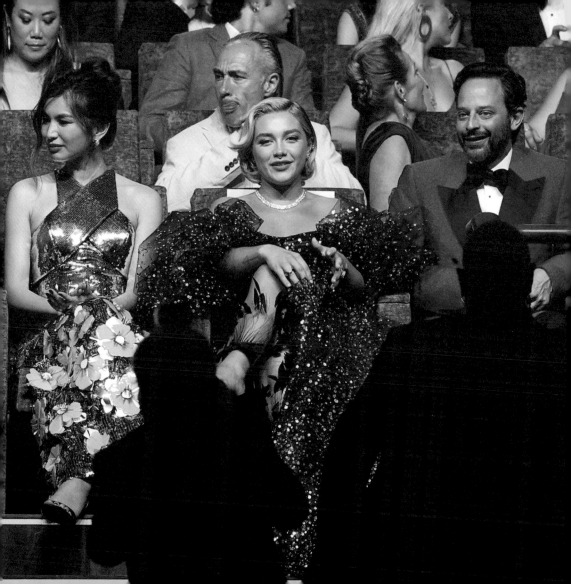

"WORKING IS NOT EVERYTHING ABOUT WHO I AM;

IT'S SOMETHING I DO."

HARRY IN ITALY

Things may not have gone entirely smoothly at the Venice Film Festival, but at least Harry got to arrive at the promotional photoshoot by speedboat across the famous canals of Venice. He stepped onto the pier looking the picture of Italian style in his light blazer and oversized sunglasses.

Harry adores Italy. He has played the 80,000-capacity San Siro stadium in Milan. He wears lots of the famous Italian designer brand Gucci. The final stop of *Love on Tour* was in Italy. In the video for "Late Night Talking", he eats spaghetti with meatballs. Case closed.

Italy even helped to inspire one the best songs on his third album *Harry's House*, "Keep Driving". In 2020, Harry and a friend took a roadtrip through France and Italy. He was spotted numerous times and fans were either thrilled or dismayed to learn he had grown a moustache in lockdown. Another thing he did in lockdown: learn Italian! Harry decided to drive home, alone, to really clear his head: "I don't travel like that a lot. I'm usually in such a rush, but there was a stillness to it. I love the feeling of nobody knowing where I am, that kind of escape... and freedom." He enjoyed the relative anonymity he had in Italy even when jogging and joining in a game of boules.

After winding his way through Europe in August, September was the month for getting back to work. Harry was spotted on Italy's stunning Amalfi Coast filming a music video, which turned out to be for "Golden". The video encapsulates Italian summer holidays, with sunset skies and Harry in lace gloves driving a convertible. Dreamy. Since this trip he has returned to Italy on holiday several times, and is often papped looking unreasonably buff on yachts.

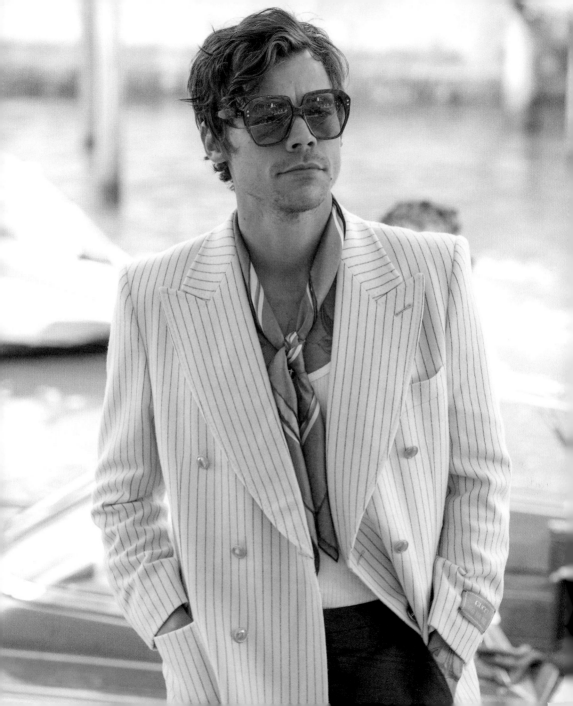

GRAMMY ALBUM OF THE YEAR

Harry's third solo album, *Harry's House*, came out on 20th May 2022. He came up with the title first and built a collection of songs that told the story of his own life as it was in 2022. He initially wanted to record an acoustic album in his house, hence the name, but the groove took over. Harry told Zane Lowe on Apple Music, "'OK, imagine, it's a day in my house. What do I go through? A day in my mind? What do I go through?'"

A day in Harry's life sounds really fun: drinking wine, going on road trips, falling in love with hot people, and wishing he got to spend more time in the UK but never managing it because of his busy schedule as an international popstar. In fact, despite all these activities ending up on the album's lyrics, he started the writing process when he was stuck at home in 2020, just like the rest of us.

Harry reflected, in an interview for *Better Homes & Gardens* magazine (clever!), that lockdown "was the first time I'd stopped since I left my mum's". It was time for him to finally stop and look back on his life so far: "I started processing a lot of stuff that happened when I was in the band."

Because this is Harry, this self-reflection didn't turn into self-pitying songs; it turned into 13 mostly upbeat bops, interspersed with empathetic stories about female experience ("Matilda" and "Boyfriends"). His goal was to "make stuff that is right, that is fun, in terms of the process, that I can be proud of for a long time, that my friends can be proud of, that my family can be proud of, that my kids will be proud of one day".

The culmination of this dream was winning music's top award, the Grammy for Album of the Year, winning over huge icons of songwriting like Adele, Beyoncé and Taylor Swift. He performed the album's huge single "As it Was" in a celestial silver-fringed jumpsuit. *Harry's House* was personal and professional high point for Harry, who says: "I've never been happier than making this album."

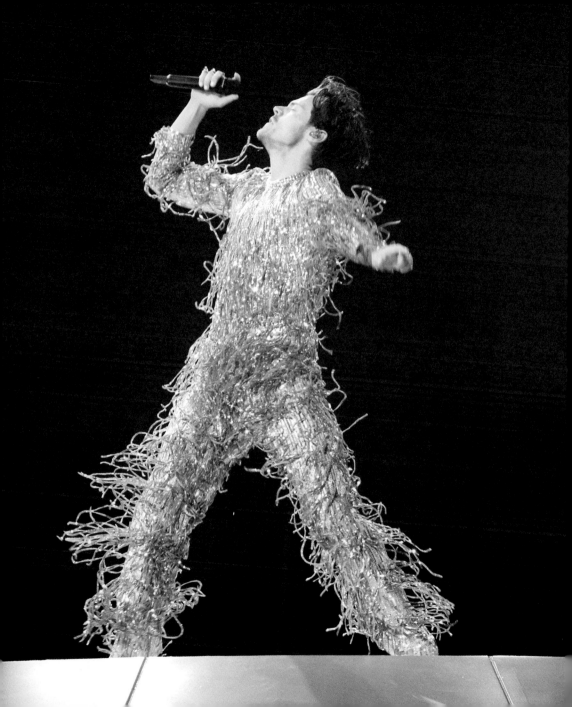

"I JUST WANT TO MAKE SOME SONGS WITH MY FRIENDS...

AND HAVE FUN."

HARRY'S STYLE

If he'd never made another album after One Direction, Harry could have still gained icon status for his style. Whenever he sets foot on a red carpet, or even goes for a run, it creates a commotion. That's the mark of a true fashionista. Of course, the exact taste that makes him so special causes meltdowns in certain people, who can't cope with a man in anything but a grey suit.

Harry told *Vogue*: "I'll put on something that feels really flamboyant, and I don't feel crazy wearing it. I think if you get something that you feel amazing in, it's like a superhero outfit. Clothes are there to have fun with and experiment with and play with." In the photoshoot that accompanied this interview, he wore a tiered blue gown and a black tuxedo jacket. He looked gorgeous and glamorous. But in among the adoring reactions were some rude and hostile ones. One commentator who claimed to be shocked by the look said: "Bring back manly men." There's no pleasing some people — Harry embodies manly virtues for the 21st century, with polite manners, a love of friends and family, and a commitment to looking dapper at all times. In fact, these are great values, no matter your gender, a fact that Harry embraces: "I don't think people are still looking for this gender differentiation. Even if the masculine and feminine exist, their limits are the subject of a game. We no longer need to be this or that."

Harry has changed the fashion game for everyone, especially other male celebrities. Movie premieres are now full of interesting male style beyond the grey suit or tuxedo. It's far more common to see boys with painted nails or wearing pearls these days. What used to cause gasps — from floral suits to floral corsages — is now everywhere. That's the Harry effect.

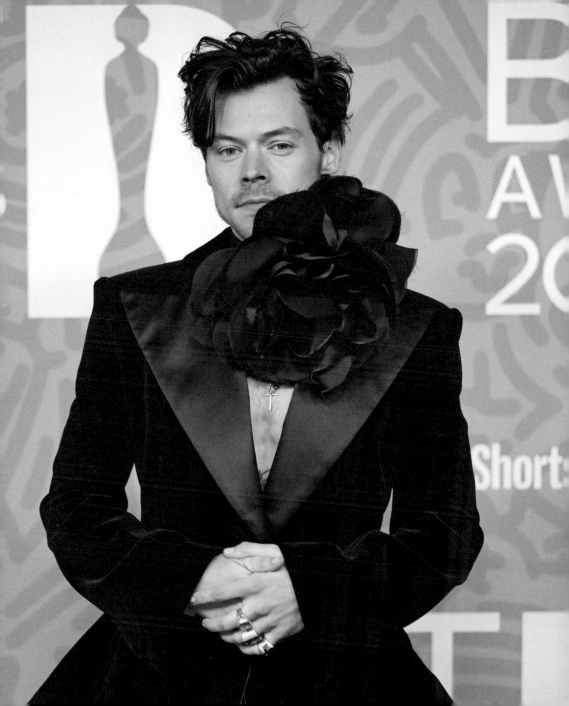

In December 2022, Harry went on Instagram to say "2022 changed my life". He has had many successful years in his decade-long career, but somehow he became even more popular with his biggest song yet, "As It Was".

The song touched a chord with everyone who had gone through lockdown and was ready to dance. Harry spoke about his experience of life changing in 2020: "Everything that happened in the pandemic, it's just never going to be the same as before. All of the things happening in the world, it's so obvious that it's just not going to be the same. You can't go backward, whether that's us as a people or me in my personal life."

"As It Was" from *Harry's House* captures the wistful feelings that come with change, but has a super-speedy and fun 1980s synth line. This brilliant combo made it the most popular song of 2022, with more streams and digital downloads across the world than any other track: 2.28 billion. It spent 15 weeks on top of the Billboard Hot 100. This song was everywhere and yet it didn't get annoying, which is the sign of a great, well-crafted song.

For his Brit Awards performance, Harry naturally chose to sing his big hit of the year. "As it Was" was nominated for Song of the Year and Harry won! When he went onstage to collect the award, it was presented to him by none other than his hero Shania Twain.

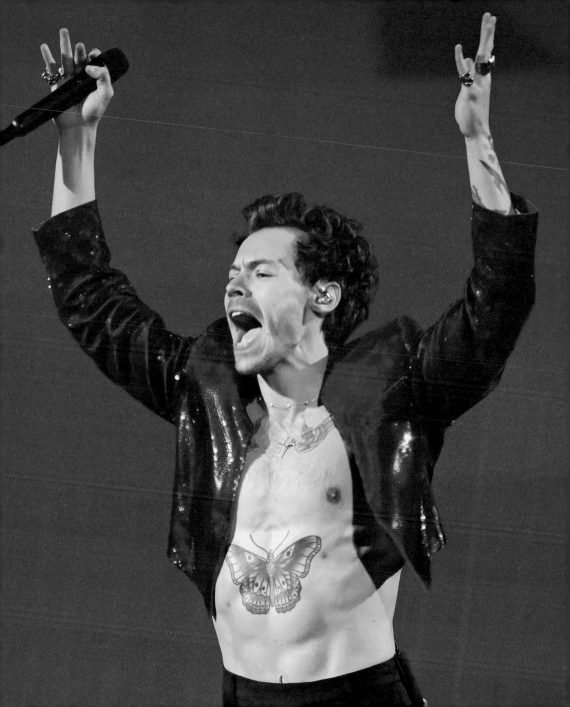

"DOING A SHOW IS MY FAVOURITE THING TO DO...

IN THE WHOLE WORLD."

LOVE ON TOUR

Harry's second solo live dates, *Love on Tour*, ran from September 2021 to July 2023, an incredible 169 concerts, including a 15-night residency in Madison Square Garden. Five million people came to see him and bought the iconic "Treat People With Kindness" tour merch, helping it become the fifth-highest grossing tour of all time. Lovely Harry donated $6.5 million of the money he made to charity.

Everywhere Harry went, he and his fans left a trail of feathers and glitter. After the final night of the tour, Harry posted on Instagram: "It's been the greatest experience of my entire life. [...] I hope you had as much fun as I did. Look after each other, I'll see you again when the time is right. Treat People With Kindness. I love you more than you'll ever know."

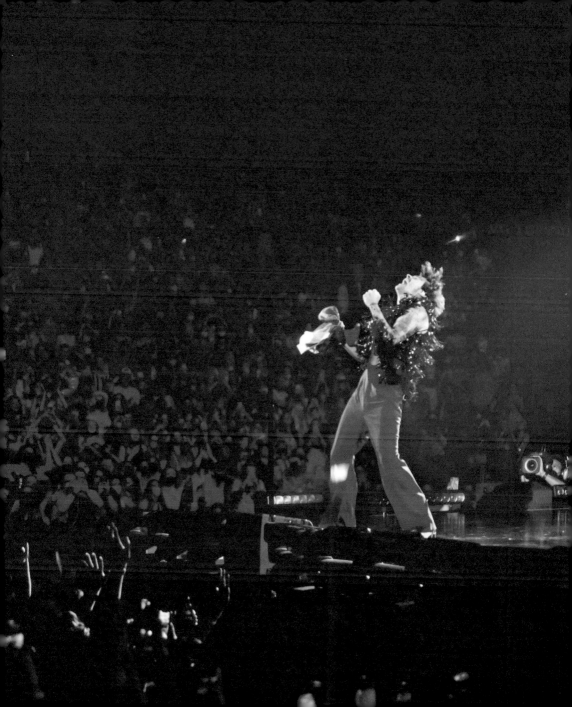

"LET'S JUST BE NICE TO EACH OTHER, TAKE CARE OF EACH OTHER...

TAKE
CARE OF
OURSELVES."

HARRY'S AWARDS

Across his career, Harry has won a huge stack of awards, as he should. Starting with One Direction, the number of awards voted for by the public or based on sales is phemomenal. Harry has won 10 American Music Awards and eight coveted MTV Video Music Awards for his music and videos.

Ultimately fans and listeners vote by streaming or buying concert tickets. Musicians often value awards from the music industry even more because it's the best way to know if they are respected by their peers. The pinnacle of music industry awards are the Grammys, but there's also awards like the Ivor Novellos, which reward songwriting skills. Harry has two Ivor Novello awards, for "Adore You" and "As It Was", and has twice been nominated for Songwriter of the Year. In an era that values authenticity and songwriting so highly,

it's important to note that Harry does co-write all his songs, which makes their success even more personal.

Harry is almost universally beloved now, but it wasn't always the case. He won "Villain of the Year" at the NME awards in both 2013 and 2014. Harry has never done anything villainous in his life, excep maybe becoming so famous so young and having his private life covered so closely. Hopefully he can feel somewhat proud for having made such a splash in the tabloids.

As well as his contribution to music, Harry's stellar contribution to being hot must also be acknowledged. *People* magazine awarded Harry the honour of "Sexiest Musician" in 2023. In the same year, the media reported that Harry was the most handsome man in the world, and his face is "perfect". We did not neec science to tell us this; it is obvious.

"DON'T LET ANYONE TELL YOU WHAT YOU'RE SUPPOSED TO DO...

WITH YOUR BODY. LET'S HAVE EACH OTHER'S BACKS..."

"WHOEVER YOU ARE, WHOEVER YOU WANT TO BE...

I SUPPORT YOU."

Published in 2024 by
Hardie Grant Books (London)

Hardie Grant Books (London)
5th & 6th Floors
52–54 Southwark Street
London SE1 1UN

hardiegrantbooks.com

British Library Cataloguing-in-Publicatio
Data. A catalogue record for this book is
available from the British Library.

Harry in 30 Images

ISBN: 978-178488-738-4

10 9 8 7 6 5 4 3 2 1

Publishing Director: Kajal Mistry
Senior Commissioning Editor:
Kate Burkett
Text by: Satu Fox
Proofreader: Caroline West
Design: Han Valentine
Indexer: Cathy Heath
Production Controller: Martina Georgieva

Colour reproduction by p2d

Printed in China by RR Donnelley Asia
Printing Solution Limited

FSC
www.fsc.org

MIX
Paper | Supporting
responsible forestry
FSC® C018179